the print room

presents

LOT AND HIS GOD
BY HOWARD BARKER

T0353286

Lot and His God
By Howard Barker

Justin Avoth – Drogheda
Vincent Enderby – Waiter
Hermione Gulliford – Sverdlosk
Mark Tandy – Lot

Director – Robyn Winfield-Smith
Designer – Fotini Dimou
Lighting Designer – Peter Mumford
Sound Designer – Gregory Clarke
Casting Director – Siobhan Bracke
Associate Lighting Designer – George Bishop
Assistant Director – Becky Caitlin

Production Manager – Andy Beardmore
Stage Manager – Bethany Sumner
Production Sound Engineer – Jonathan Jones
Scenic Painter – Natasha Shepherd
Set Builder – Clockwork Scenery

For The Print Room
Artistic Director – Anda Winters
Producer – Veronica Humphris
Line Producer – Emily Vaughan-Barratt
Development Officer – Julia Gale
Production Assistant/FOH Manager – Isobel David
Theatre Intern – Claire Law
Master Carpenter – Rodger Pampilo
Press Representative – Mobius Industries
Production Trailer Filmaker – Matt Bartlett
 for nothinordoublefilms
Cover Photography – Zadoc Nava

Thanks to Gerrard McArthur, Melanie Jessop and all
at the Wrestling School, Ben Cooper and Sue Emmas at
the Young Vic, Howard Gooding, Catherine Cusack, Fiona
Hampton, Kieron Jecchinis, Nick Le Prevost, Emmeline
Prior, Liam Smith, Blanche McIntyre, Sheila and John
Belson, Ben Stones, Dolja Gavanski.

HOWARD BARKER

Howard Barker was born in a working-class family in South London in 1946. His first stage play was performed in 1970 at the Royal Court. Subsequently, his works were played by the Royal Court, Royal Shakespeare Company, the Open Space Theatre, Sheffield Crucible and the Almeida. His early nausea with social realism, his embracing of tragedy 'the greatest art form known to man', his poetic discourse, and what he calls 'a suffocating unanimity of critical and theatre opinion' served to isolate him from mainstream theatre in this country, whose culture he describes as 'utilitarian, entertainment-obsessed and awash with moral platitudes.' Such solitude has been compensated by a powerful and growing international reputation and the formation of 'The Wrestling School', a company specifically created to develop his theories of theatre, now in its twenty-fourth year. Barker sees his mission as developing a 'conscience-free, speculative, tragic theatre speaking its own language...' He describes his greatest achievement as earning world-wide status without compromising his principles. His work is played extensively in Europe, in translation, in the United States, and in Australia. He is the author of plays for marionettes and has written three librettos for opera. Howard Barker is the author of two works of theory, and five volumes of poetry. He is also a painter. His work is held in national collections in England (V&A, London) and Europe.

CAST

JUSTIN AVOTH – DROGHEDA

Theatre includes: *The Only True History of Lizzie Finn* (Southwark Playhouse), *Our Brother David* (Watford), *A Midsummer Night's Dream* (Headlong Theatre Company), *Beasts and Beauties* (Hampstead Theatre), *Molière* (National Theatre/Finborough Theatre), *As You Like It* (Curve, Leicester), *De Montfort, Chains* (Orange Tree Theatre), *Hamlet* (Southwark Playhouse), *Nathan the Wise* (Hampstead Theatre), *Dead Hands, 13 Objects, Gertrude – The Cry* (The Wrestling School), *Othello* (RSC), *Edward II* (Shakespeare's Globe), *A Midsummer Night's Dream* (Royal Exchange, Manchester – commended for Ian Charleston Awards), *The Ash Girl, True Brit* (Birmingham Rep), *The Snow Palace* (Tricycle Theatre), *The Tempest* (City of London Festival), *Venice Preserved* (Almeida Theatre), *King Arthur* (Royal Opera House/Chatelet Theatre de Paris), *Richard III* (Arts Threshold),*The Government Inspector* (Harrogate Theatre). Television includes: *Ripper Street, Dark Matters, Whitechapel, The Borgias, Holby City, Midsomer Murders, Spooks, Merlin, Judge John Deed, Coronation Street, Persuasion.*

VINCENT ENDERBY – WAITER

Vincent graduated from Drama Centre London in 2009. During his three years of training he was cast in *Hamlet, Three Sisters, A Flea In Her Ear* and *The Government Inspector.*
Theatre includes: *Macbeth* (Cheek By Jowl), *The Duchess of Malfi* (Eyestrings Theatre Company).
Television includes: *Doctors.*

HERMIONE GULLIFORD – SVERDLOSK

Theatre includes: *The Way of the World, The Critic, The Real Inspector Hound, Three Sisters* (Chichester), *Drama at Inish* (Finborough), *Arcadia* (Bristol Old Vic), *The Merchant of Venice, A Midsummer Night's Dream, Antony and Cleopatra* (RSC), *The Country Wife, Twelfth Night* (Sheffield Crucible), *Happy Savages* (Lyric Hammersmith), *Hay Fever, The Rehearsal, The Double Inconstancy, Time and the Conways* (Salisbury Playhouse) *The Importance of Being Earnest* (The Old Vic). Television and Film includes: *Call the Midwife, Utopia, Lewis, Upstairs, Downstairs, Hustle, The IT Crowd, Rev, Doctors, Holby City, M.I. High, Midsomer Murders, Kingdom, All About George, The Brief, Heartbeat, Monarch of the Glen, Carrie's War, Oktober, Jane Eyre, The Bill, The Affair of the Necklace, Stage Beauty.*
Radio includes: *Blithe Spirit.*

MARK TANDY – LOT

Theatre includes: *Racing Demon* (Sheffield Crucible), *Mrs Warren's Profession* (Comedy Theatre/Theatre Royal Bath), *The Voysey Inheritance, Luther, Mountain Giants, Major Barbara* (National Theatre), *Othello, Julius Caesar, Merry Wives of Windsor, Nicholas Nickleby* (RSC), *Richard II, Beauty and the Beast* (Old Vic), *Beside Herself, The Lucky Chance* (Royal Court), *Sweet Panic* (Hampstead), *Siblings* (Lyric Hammersmith), *The Years Between* (Orange Tree Richmond), *Reflected Glory* (Vaudeville).

Television and Film includes: *Henry IV Parts 1 and 2, Silk, Garrow's Law, Shackleton, The Alan Clark Diaries, Darwin, Longitude, Trial and Retribution, The Waiting Time, The Buchaneers, Absolutely Fabulous, A Time to Dance, Fall from Grace, Portrait of a Marriage, A Vote For Hitler, Jewel in the Crown, The Deep Blue Sea, Mr Nice, A Cock and Bull Story, Bridget Jones – The Edge Of Reason, The Luzhin Defence, The Biographer, Sophie's World, Mrs Dalloway, Food of Love, Howards End, The Railway Station Man, Duel of Hearts, Wings of Fame, Loser Takes All, Maurice, Captive, Defence of the Realm.*

CREATIVE TEAM

ROBYN WINFIELD-SMITH – DIRECTOR
Directing includes: *Ink: A Tale of Captivity* (Tristan Bates), *Judith: A Parting from the Body* (Cock Tavern), *A Game at Chess* (rehearsed reading, Birkbeck), *Statements After an Arrest Under the Immorality Act, Blood Wedding* (Warwick Arts Centre). For The Print Room: a reading of *The Twelfth Battle of Isonzo* by Howard Barker. Associate and Assistant directing includes: *The Changeling* (Southwark Playhouse), *Read Not Dead* Season 2011 (Shakespeare's Globe), *Kingdom of Earth* (The Print Room), *It's Raining in Barcelona, There Will Be More* (Cock Tavern), *Play Pod* (Minerva), *Anna Karenina, Closer* (WAC), *Caucasian Chalk Circle* (Minerva).

FOTINI DIMOU – DESIGNER
Fotini trained as set and costume designer at the Central St Martins school of Art and Design after studying Fine Art for a year at the Ecole des Beaux Arts de Boitsfort in Brussels, Belgium. After her studies she spent five years working in the US as a set and costume designer in New York, and as Resident Costume Designer at the Alley Theatre in Houston, Texas. Since then she has been working extensively in the UK, as well as Europe, with major national and commercial Theatre, Opera and Dance companies. Fotini also designs costumes for TV drama, commercials and feature films.
Theatre credits include: *The Duchess of Malfi, The Castle, A Jovial Crew, The School of Night, The Archbishop's Ceiling, Ion, Fashion, The Storm, Speculators, Julius Caesar, The Crucible* (RSC), *Gethsemane, Fram, Thérèse Raquin, The Secret Rapture, The Seagull* (National Theatre), *Sore Throats, Road, Some Singing Blood* (Royal Court), *The Queen and I* (Royal Court and Vaudeville), *Rosencrantz and Guildenstern Are Dead, The Last Confession* (Chichester Festival Theatre and Theatre Royal Haymarket), *Creditors* (Donmar and Brooklyn Academy of Music), *Girl with a Pearl Earring* (Theatre Royal Haymarket and UK Tour), *Hay Fever, Saturday, Sunday, Monday* (Chichester Festival Theatre), *Romeo & Juliet* and *Twelfth Night* (Open Air Theatre, Regent's Park). Film and Television credits as Costume Designer include: *Skin, Desert Dreams, Man and Boy, Ripley's Game, Second Sight, The Writing Game*, and *The Browning Version*.
Opera and Ballet credits include: *Dido and Aeneas* (Royal Opera House), *Eugene Onegin* (ENO), *The Sarlatan* (Wexford Opera Festival), *Naked, Stampede* (Sadler's Wells), *White Nights and Encounters* (English National Ballet).

PETER MUMFORD – LIGHTING DESIGNER

Recent Theatre includes: *Top Hat, Jumpy, Absent Friends, Much Ado about Nothing, The Lion in Winter, The Misanthrope, An Ideal Husband, Carousel, Fiddler on the Roof, Love and Information* (The West End), *Our Private Life, Sucker Punch, Cock, The Seagull, Drunk Enough to Say I Love You, Dying City* (also set design) (Royal Court Theatre), *A Taste of Honey, Betrayal* (Sheffield Crucible), *The Last of the Duchess* (Hampstead Theatre), *Testament* (Dublin Theatre Festival), *A Streetcar Named Desire* (Guthrie Theater, Minneapolis), *Heartbreak House* (Chichester Festival Theatre), *Pictures from an Exhibition* (Young Vic), *Parlour Song, Hedda Gabler, Cloud Nine* (Almeida), *Scenes from an Execution, All's Well That Ends Well, The Hothouse, Exiles* (National Theatre).

His Opera and Dance credits include *The Damnation of Faust, Lucrezia Borgia, Elegy for Young Lovers, Punch and Judy* (also Geneva), *Bluebeard's Castle, Madam Butterfly* (English National Opera), *Faster, E=MC²* (Birmingham Royal Ballet), *Pelléas and Mélisande* (Mariinsky), *The Soldier's Tale* (Chicago Symphony), *Madame Butterfly, Faust, Carmen, Peter Grimes, 125th Gala* (New York Met), *Eugene Onegin* (LA Opera/ROH), *Passion* (Minnesota Opera), *La Cenerentola* (Glyndebourne), *Carmen* (also set design), *Petrushka* (Scottish Ballet), *Il Trovatore* (Paris), *Fidelio, Two Widows, Don Giovanni, The Ring* (Scottish Opera), *The Midsummer Marriage* (Chicago Lyric Opera), *The Bartered Bride* (Royal Opera House). He is currently directing/designing a concert version of *The Ring Cycle* for Opera North.

Awards include 1995 Olivier Award for Outstanding Achievement in Dance for *The Glass Blew In* (Siobhan Davies) and *Fearful Symmetries* (Royal Ballet), 2003 Olivier Lighting Award for *The Bacchai* (National Theatre). Knight of Illumination Award 2010 for *Sucker Punch* at the Royal Court.

GREGORY CLARKE – SOUND DESIGNER

Theatre includes: *Uncle Vanya* (The Print Room), *Misterman* (also Galway and New York), *Twelfth Night, No Man's Land, Tristan & Yseult, The Emperor Jones, Earthquakes in London* (National Theatre), *Penelope, The Hackney Office, The New Electric Ballroom, DruidMurphy* (Druid), *Journey's End* (London and Broadway, New York Drama Desk award-winner for Outstanding Sound Design), *Equus* (London and Broadway, Tony Award winner for Best Sound Design), *Pygmalion, The Philanthropist* (American Airlines, Broadway), *Great Expectations, Coriolanus, The Merry Wives of Windsor, Tantalus, Cymbeline, The Merchant of Venice, A Midsummer Night's Dream, The*

Heart of Robin Hood (RSC), *Peter Pan* (Kensington Gardens and on US tour), *The Changeling, Troilus and Cressida* (Barbican), *A Month in the Country, Seven Doors, Semi–Detached, Pal Joey, Heartbreak House, A Small Family Business, I Caught My Death In Venice, Nathan The Wise, Song of Singapore, Nymph Errant* (Chichester), *Pygmalion, Measure For Measure, Habeas Corpus, Private Lives, Much Ado About Nothing, Design for Living, As You Like It* (The Peter Hall Company), *Bay, My Dad's a Birdman* (Young Vic), *A Voyage Round My Father, The Vortex, Cloud Nine, The Philanthropist, And Then There Were None, Some Girls, Waiting for Godot, What the Butler Saw, The Dresser, Amy's View, You Never Can Tell, A Flea In Her Ear, National Anthems, Six Degrees of Separation, Betrayal, Abigail's Party, Bedroom Farce* (The West End), *The Wind in the Willows* (Birmingham Rep), *Dandy Dick, Blue/Orange* (on tour for ATG), *Copenhagen* (the Lyric, Sheffield), *Testament* (Dublin Theatre Festival and Landmark Productions).

The Print Room is generously supported by:

the print room

'The Print Room has fast become one of the most exciting fringe venues in London, and the finished product reaffirms what I've long suspected about The Print Room: that every production it programs turns into a must-see'
The Spectator

History

In 2008, we discovered this 1950's warehouse that had served as a graphic design workshop and office complex. The building's owner generously offered us the use of the space which we converted into a flexible studio theatre and adjoining exhibition space. The Print Room's first Co-Artistic Directors, Lucy Bailey and Anda Winters, officially opened The Print Room in September 2010 with the help of many supporters and friends. Under their joint Artistic Directorate The Print Room has presented six plays, four art exhibitions, a festival of multi-disciplinary work, eleven concerts, a holographic opera and a dance/sculpture collaboration.

Two years on, we are overwhelmed by the positive feedback we are receiving from our audiences and critics alike. To date, we have been awarded two Offies (Best Designer for *Kingdom* of Earth; Best Sound Design for *Snake in the Grass*), and received a nomination for the Peter Brook Empty Space award.

This is how we want to continue – staging exciting undiscovered pieces by great writers, and working with emerging and talented artists from all fields.

We are a privately funded charity that receives no public money. As such, we are dependent on the generosity of our supporters to present our work. We would like to thank all our supporters, colleagues and friends who have helped us on our journey so far. We would not be here without their kind support.

LOT AND HIS GOD

Howard Barker

LOT AND HIS GOD

OBERON BOOKS
LONDON

WWW.OBERONBOOKS.COM

Published in *Barker: Plays Six* in 2010 by Oberon Books Ltd
Published in a single edition by Oberon Books Ltd in 2012
521 Caledonian Road, London N7 9RH
Tel: +44 (0) 20 7607 3637 / Fax: +44 (0) 20 7607 3629
e-mail: info@oberonbooks.com
www.oberonbooks.com

Reprinted in 2012

A catalogue record for this book is available from the British Library.

PB ISBN: 978-1-84943-409-6
Digital ISBN: 978-1-84943-680-9

Cover photography by Zadoc Nava

Contents

Characters

DROGHEDA
An Angel

SVERDLOSK
The Wife of Lot

LOT
A Citizen of Sodom

WAITER
An Object of Contempt

I

An angel seated in a café.

DROGHEDA: I came to the city. I saw the people were filthy.
And those who were not filthy were still filthy. The filth
of those who were not filthy was not in their acts or even
in their thoughts but in their permission, for permission is
filthy if the thing permitted is filthy. And I saw no one and
heard no one who withheld this permission. Therefore the
filth was divided equally between those who practised filth
and those who looked on filth without revulsion. I reported
this and was praised for my report...

*(A woman enters. She sits swiftly at the table. She casts a glance
about her...)*

SVERDLOSK: I'm not leaving...

(She bites her lip.)

Leave leave all you hear is leaving perhaps people should
leave less perhaps less leaving altogether would be nice
I-don't-like-it-I'm-leaving well you can't you can't leave try
staying instead staying and fighting or not fighting I don't
care what are you anyway a rat rats leave rats are famous
for it be a rat for all I care but don't ask me to be one pack
your bags you say so casually pack your bags do I look like
a woman who packs her bags look at me the hat the gloves
the

(DROGHEDA appears absent-minded...)

I'm talking to you the hat the gloves I'm talking to you I'm
talking to you

(DROGHEDA drags his gaze back to SVERDLOSK.)

The shoes they match my husband collects books five
thousand books he has some from the fourteenth century
the fourteenth century fragile and priceless fourteenth

19

century books and you say pack your bags that look I
hate that look that exasperated look no I'm not going
anywhere too bad if it exasperates you is he supposed to
burn his books and me I live for shoes do you know the
more offended you look the more pleasure I discover in
offending you pack your bags tell them pack theirs does
anybody serve you here why do you always sit in dirty
cafes there is a clean one over there perfectly clean and
they like to serve good-morning they say and they serve
I thought when I first set eyes on you he has a certain
tolerance for dirt not squalor dirt used things smeared
things to touch the unclean scarcely troubles him whereas
I already I want to wash my hands I'm wearing gloves but
still I want to wash my hands

(She stands swiftly.)

Is there a sink here you would know no no

(She sits as swiftly.)

It doesn't matter no imagine the sink imagine the soap the
cracked and sordid soap a perfect culture for pathogens
as for the towel imagine it not that I ever use the towel
however pristine is the towel still I ignore its blandishments
shaking my wet fingers in the air I do so love to embarrass
you the woman's mad the hatted woman the woman in
the hat and gloves quite mad he must be in love with
her a servile love not nice not healthy and she smacks
him probably the point is I am not leaving neither is my
husband

*(She looks at the ground. Her foot bounces… DROGHEDA gazes at
her…time passes…)*

DROGHEDA: My feelings with regard to you are complicated
on the one hand I despise your obsessive and frankly
pitiful self-regard but on the other I have to confess to a
certain admiration for the stubbornness with which you
cling to it it is not as if you were oblivious to the futility
of the life you have just described the gloves the shoes

the hats etcetera you are perhaps incapable of shame
apology or even mild regret a thing oddly attractive to me
and not me only many men I notice stare at you though
these lingering regards are tainted with an apprehension
you might drag them to their deaths death is not a dread
of mine but humiliation might be as for packing bags in
saying pack your bags I was excessively considerate you
should go in what you stand up in or nothing at all yes go
naked you degraded bitch the dirty cafes I choose for our
rendezvous complement your character

(His gaze is fixed on her…)

SVERDLOSK: You do love me

(She leans back in her chair, plucking her skirt…)

You love me and it drives you mad I am not driven
mad by you still no service how long have we been
here perhaps if you were less taut less stiff less bitter less
everything in fact some slovenly individual might pluck
up courage and take our order we are giving wittingly
or unwittingly the impression of a desperately unhappy
couple no wonder no one intervenes we are not an
unhappy couple we are not a couple at all you love me and
I love my husband that's it that's it that's all there is to it

(She plays with a glove…)

Call me bitch again degraded bitch say it again go naked
dirty bitch say

(DROGHEDA is unwilling…)

A funny couple we would be you a little filthy me
scrupulously clean your filth as artificial as my cleanliness
as for the disparity in our ages why won't you say it naked
bitch either you meant to say it or you did not if you meant
what you said surely it can be said again if you were simply
irritated if those words were so to speak expletives then
apologize

(She challenges DROGHEDA with her gaze.)

Here he comes no he doesn't

(She looks askance.)

He doesn't

He doesn't

That woman came in after me long after me you see he
skirts our table anyone would think we suffered from some
communicable disease and frankly you look unhealthy
an affectation obviously but how should he know that
apologize or call me bitch degraded bitch one or the other

(Pause.)

You would like to say the words again but because I want
to hear the words the words have lost their charm for you
very well invent some other words worse words preferably
degraded bitch I liked but how mild that is mild abuse is
silly and what might have satisfied me only minutes ago
could only disappoint me now so very altered are our
circumstances my husband look my husband searching
for us no we have entered a crueller sphere you and I
harder and crueller altogether call him he is short-sighted
the consequence of reading documents printed in the
fourteenth century he's seen us he's seen us pull up another
chair

(DROGHEDA fetches a third chair as LOT enters.)

Darling

(She kisses LOT's cheek.)

We are quarrelling Mr Drogheda and I quarrelling in an
amicable way at least it was amicable to begin with it is
less amicable now he began by urging me to pack my bags
I recoiled from the suggestion whereupon he called me
a degraded bitch I was both shocked and charmed and
begged him to repeat it he declined to so you see your

arrival is timely things might have got a lot worse there is
a friction between Mr Drogheda and I possibly of a sexual
nature I say possibly it's obvious he used the word naked
naked naked he said and the service here is terrible by
terrible I mean non-existent

*(SVERDLOSK opens her handbag. She takes out a compact. She
looks at herself in the mirror. At last LOT sits in the chair proffered
by DROGHEDA. DROGHEDA does not sit at once but leans with his
hands on the back of his own chair…)*

DROGHEDA: Your wife infuriates me

(SVERDLOSK lets out a bemused cry. She plucks at a stray hair…)

My announcement of the imminent destruction of this
place and every single one of its inhabitants provoked in
her a perverse and frankly infantile reaction a reaction
which even on a brief acquaintance might have been
predicted what was less predictable was my own equally
perverse and infantile frustration with her intransigence
I admit that under extreme provocation I described your
wife in terms I now regret terms to which she ascribes a
sexual character

(SVERDLOSK lets out a further cry of mockery.)

Fortunately your appearance puts an end to any
further deterioration in the situation I am a messenger
a complacent messenger perhaps given I assumed my
warning could have only a single consequence namely that
the pair of you would pack your bags and quit the city in
this confidence I was naïve perhaps perhaps I say perhaps
I am reluctant to admit a weakness certainly I was naïve
here comes a waiter no he doesn't

(Pause. He sits… at last LOT speaks.)

LOT: We like it here

(DROGHEDA regards LOT with a certain disdain.)

DROGHEDA: Here?

You like it here?

SVERDLOSK: He doesn't mean here when he says here he
means Sodom he does not mean here how could anybody
like it here obviously not here you did not mean here did
you not this squalid parody of a café you meant the city
didn't you he meant Sodom

(SVERDLOSK snaps shut her compact.)

LOT: I meant Sodom

(Pause.)

I meant Sodom on the other hand I think I have to say
it would be inconsistent of me to declare as I have to Mr
Drogheda that I liked the city of Sodom but in the next
sentence to affect a revulsion for this filthy café which in
its every aspect expresses Sodom not least in its filth I
think we could safely say of this place that its ugliness its
decrepitude and the slovenliness of its waiters is scarcely
accidental rather these are aspects of a perverse fashion

(Pause. SVERDLOSK is gazing at DROGHEDA...)

SVERDLOSK: He is too clever for me

LOT: I am not too clever for you and you are a liar to say so
it is a lie you have played with for forty years never mind
every man must have his lie and every woman

SVERDLOSK: I love you

LOT: Of course you do and here comes the waiter

(He casts a glance off...)

In accordance with what I have just described he will
demonstrate a reluctance to accept our order if he wipes
the table at all it will be with a disgusting cloth and at no
point in the transaction will he meet our eyes all in all he
will exert himself to be unremittingly offensive strangely

this entails more effort than common politeness would but this is Sodom you talk to him I won't

(A WAITER appears, young and slovenly. He proceeds to justify every one of LOT's speculations, beginning with a cursory wiping of the tin table. They watch him in silence. At last he indicates a willingness to take their order but DROGHEDA stands abruptly, accidentally toppling his chair in his resentment...)

DROGHEDA: *(Bitterly.)* I'm blinding you

(The WAITER lifts his gaze to DROGHEDA, a gaze full of contempt. SVERDLOSK acts swiftly to end the confrontation.)

SVERDLOSK: Three coffees coffee is it coffee darling three coffees and cold milk the cold milk separately

(DROGHEDA retrieves his chair. The WAITER idles and departs. DROGHEDA sits...)

LOT: Don't blind him

DROGHEDA: Too late he's blinded

LOT: You are impetuous Mr Drogheda and as a consequence we shall never be served though it has to be said that were we to be served we might have cause to regret it

(An appalling cry from a distance... DROGHEDA stares at the table. SVERDLOSK bites her lip, her gaze fixed on DROGHEDA. LOT looks over his shoulder in the direction of the cry.)

If I have learned one thing from living as we have for thirty years in such a place as Sodom it is this that however unregulated things seem eventually they are regulated you are of course the regulator

DROGHEDA: He offended me

LOT: Yes

DROGHEDA: Precisely as you described

LOT: Yes

DROGHEDA: He is a waiter and he claimed ascendancy over me

LOT: He did his whole manner was insubordinate even his way of standing

DROGHEDA: As for the cloth

LOT: Filthy

DROGHEDA: And the way he moved the cloth

LOT: Calculated to humiliate the customer do you intend to blind the others they are animated suddenly like a swarm of bees

DROGHEDA: Yes

LOT: And some have kitchen knives

SVERDLOSK: *(Apprehensive.)* Blind them

LOT: It is one of the characteristics of Sodom that whereas the citizens seem for the most part to exist in a condition of self-induced torpor

SVERDLOSK: *(Alarmed.)* Blind them

LOT: It takes surprisingly little to induce them to erupt into a frenzy

SVERDLOSK: Blind them darling

LOT: Knives guns bottles clubs the official description of Sodom as a place of pleasure and civility is routinely contradicted as you see

SVERDLOSK: *(Rising from her chair in her terror.)* DARLING BLIND THEM PLEASE

(A torrent of cries and curses… SVERDLOSK resumes her seat.)

Darling I said Mr Drogheda is not darling to me I called him darling presumably because

(The whimpering of stricken men…)

Because

Because a woman exposed to danger inevitably invokes the prospect of intimacy with whomsoever possesses the wherewithal to save her in this instance this individual was Mr Drogheda it was instinct instinct and expediency on the other hand

(She falters...the WAITERS are mournful...)

I am attracted to Mr Drogheda

LOT: Obviously and his angelic powers lend him a charm which surely abolishes any reluctance a woman might have entertained given his self-neglect though that too might be an inducement to an immaculate and pristine woman such as you

(To DROGHEDA.)

Do you intend to leave them like that?

(DROGHEDA shrugs.)

Crawling crying for their mothers apologizing and so on in a minute they will find our feet and slobber over them and after feet it will be knees it's unedifying don't you think?

(DROGHEDA regards the spectacle with indifference...)

DROGHEDA: I am not here to save them I am here to save you

LOT: I should like to explain why that is not the simple matter it seems to be to you but the complaints of these

DROGHEDA: I'll silence them and then we must get on

LOT: No please

(DROGHEDA casts a glance at LOT.)

I mean let us get on but I would prefer it if you refrained from adding to their suffering by inflicting them with whatever

SVERDLOSK: Dumbness

LOT: Dumbness for example yes

DROGHEDA: They're as good as dead

(Pause.)

LOT: Yes

Yes

And so are we only

(A sudden silence falls over the cafe…)

I should not have interceded for them

(DROGHEDA shrugs…)

My pity condemned them to a further swathe of agony I must learn to keep my mouth shut when there are angels in the room whatever an angel may or may not be we can be sure of one thing he is not inhibited by considerations of humanity and why should he be since he is not human now they are waving their arms in the most pitiful way like waterweed in currents much worse I think to behold than their wailing was to listen to BUT I SAY NOTHING I ASK NOTHING IGNORE MY LITTLE TWITCH OF SYMPATHY

(DROGHEDA regards LOT with contempt…)

DROGHEDA: Your vanity is preposterous

LOT: Is it?

Possibly

Possibly I'm vain

My wife has made similar complaints of me

DROGHEDA: Neither of my actions either in blinding or making dumb the insolent waiters was inspired by the desire to frustrate your kindness

LOT: I apologize

DROGHEDA: If it was kindness

LOT: I think it was but it may not have been

DROGHEDA: As you say it may not have been you perhaps might wish to consider the paradox of kindness in the solitude of your library if you ever again enter your library which you may you may prefer your library to the will of God sadly you will not have long in which to enjoy it let alone resolve paradoxes of this magnitude I am here to urge you to pack your bags that's all just pack your bags and go that's all why I have lingered here so long I do not know

SVERDLOSK: You know perfectly well

DROGHEDA: Do I?

SVERDLOSK: Yes

It's me

DROGHEDA: It is you yes I was being disingenuous and the more you insist on it the more convinced I become that I cannot leave until I have enjoyed some intimacy with you what kind of intimacy I don't know what kind of enjoyment I don't know either perhaps no enjoyment at all the fact you state these things out loud before your husband is

SVERDLOSK: He's used to it

DROGHEDA: Is

SVERDLOSK: Thirty-seven years I have loved my husband

DROGHEDA: Is

SVERDLOSK: Thirty-seven

DROGHEDA: A calculated provocation obviously I am not naïve but still the provocation works I am aroused and he looks suitably long-suffering his mouth is shaped by pain

and certainly if he were not in pain we both know none of this could satisfy me

(LOT suddenly rises from his chair, indifferent to DROGHEDA's discourse but shaken by the wretched appearance of the WAITER who, blind and dumb, is crawling over the floor…)

All of which causes me to wonder if I am not the subject of some domestic game marriage is an unpredictable and frequently delinquent institution but if you are playing with me I have succumbed the only question is

LOT: *(Staring at the WAITER.)* Put him out of his misery why don't you

DROGHEDA: What happens next?

LOT: *(To DROGHEDA.)* YOU ARE TORTURING THIS MAN

SVERDLOSK: Not a man

LOT: THIS YOUTH YOU ARE TORTURING THIS YOUTH

DROGHEDA: All the time you resort to exaggeration have you noticed that exaggeration and hyperbole?

SVERDLOSK: And he is a scholar with books dating from the fourteenth century

DROGHEDA: The scholar exaggerates

SVERDLOSK: I blame the library

DROGHEDA: Why?

SVERDLOSK: He sits alone in there day after day don't you darling you see no one?

LOT: I see you

SVERDLOSK: You see me but very few others and this I think contributes to a certain sense of unreality everything disturbs you

LOT: I AM DISTURBED BY CRUELTY I AM DISTURBED BY
TORTURE

DROGHEDA: It is not torture it is punishment a man of your
distinction can surely discriminate between the two?

SVERDLOSK: He can't

DROGHEDA: Perhaps he can't and certainly it is one of the
characteristics of Sodom I have found the most irritating
worse even than the universal depravity but they are
contingent one upon the other are they not if one cannot
distinguish between words

(The stricken WAITER dimly grasps the air…)

how might one distinguish between values it's not possible

LOT: *(Rising from his chair.)* I cannot sit and watch this

SVERDLOSK: Sit down

LOT: I will not sit down

DROGHEDA: All right stay standing but before you become
any more shrill in your indignation perhaps you should
recollect who it was initiated all these actions the
consequences of which you now pretend to find intolerable

LOT: I don't pretend and they are intolerable

DROGHEDA: It was you

LOT: NEVER DID I

DROGHEDA: Recollect I said

LOT: NEVER WOULD I

DROGHEDA: Never would you speak the words but all the
same you know perfectly well who it was encouraged me

SVERDLOSK: It was me

DROGHEDA: It was you but your husband was no less
responsible

SVERDLOSK: He has a tone

DROGHEDA: A tone yes you could call it a tone

SVERDLOSK: The tone adopted by my husband enabled me to issue the command it's strange how that happens the blinding and the dumbing certainly were done by you but the atmosphere in which this blinding could be perpetrated was created by my husband his wit contempt disdain etcetera on reflection in giving the order to blind I feel I was the least reprehensible if any of us is reprehensible at all he is holding my foot he is weeping and holding my foot such a different attitude he was menacing ten minutes ago now he's

(She laughs…)

YOU'RE TICKLING ME

(LOT stares at the spectacle of his wife and the WAITER…)

DROGHEDA: Let's talk about God's will for a minute I say a minute it need not take that long

SVERDLOSK: *(To the WAITER.)* STOP IT

DROGHEDA: I think you know what His will is the only question is when and if you are conforming to it it's funny I really want a coffee now possibly because I know I cannot have one of course we could go somewhere else there is a café over there where when they wish you good-morning it is sincere apparently

LOT: No

DROGHEDA: You see you like conditions to be sordid mildly sordid mildly chic I am beginning to understand you your wife is more complicated

LOT: It isn't chic here it is horrible

DROGHEDA: All the more reason to go elsewhere

LOT: We have inflicted awful things on these

SVERDLOSK: *(Standing.)* I have to move

LOT: These harmless and

SVERDLOSK: *(To the WAITER.)* LET ME GO LET ME GO

LOT: Inoffensive

SVERDLOSK: *(Lifting her chair and moving it a few feet.)* They are inoffensive now they were not inoffensive twenty minutes ago

LOT: I AM NOT MOVING

(He sits. He bites his lip…)

Look at them, oh look…

(He shakes his head…)

DROGHEDA: When I urged your wife to pack her bags she was knowingly or unknowingly profoundly seductive in the vehemence with which she repudiated the proposition and I confess the erotic character of our quarrel still influences me or I should have left here long ago after all what I have to say is scarcely complicated her attitude to the waiters for example is in stark contrast to your own if she has pity for them she does not advertise it whereas you

SVERDLOSK: *(To DROGHEDA.)* Kiss me

(Pause. DROGHEDA looks at SVERDLOSK without moving.)

LOT: In requiring my wife and I to abandon Sodom God was possibly and I hesitate to interpret Him possibly rewarding my fidelity to Him and I am thankful there are other considerations however considerations unrelated to my library or any other property property is not the issue

DROGHEDA: *(To SVERDLOSK.)* Kiss?

LOT: So what if the books date from the fourteenth century decay is decay no it's not the books

SVERDLOSK: *(To DROGHEDA.)* You don't want to kiss?

DROGHEDA: I don't know

LOT: Please confirm to God that Lot for all his love of
 literature was not constrained by it no this is a matter of
 ethics not property

DROGHEDA: Your ethics are paltry

LOT: Possibly

DROGHEDA: A self-indulgence

LOT: Possibly

DROGHEDA: And of negligible interest to God I don't know
 why the invitation to a kiss is not more compelling to
 me obviously of all the intimacies available to us the
 kiss must always be appreciated as the greatest as well as
 conventionally the first nothing that occurs subsequently
 replicates the splendour of the kiss except a further kiss all
 the same I

 (He makes a futile gesture.)

 No let's start with the kiss

SVERDLOSK: Wait

 Wait

 (She opens her handbag…)

 Your meditation on the theme of kissing has abolished
 any spontaneity that might have lingered in the obscure
 channels of our relationship Mr Drogheda on the other
 hand I am not so infantile as to think spontaneity is
 evidence of desire on the contrary desire is frequently
 constrained by its integrity all the same I feel licensed by
 your thoughtfulness to admit my own equivalence

 (She takes out a mirror and lipstick.)

 My lips for such a kiss

 (She pouts. She applies the lipstick.)

LOT: *(Who has watched the WAITER's ordeal.)* Oh my poor boy oh my poor poor boy

(He stands. He takes the WAITER and assists him into his vacant chair.)

Sit

Sit

SVERDLOSK: My lips require this imitation of perfection

LOT: He hears us he hears everything

DROGHEDA: Imitation?

SVERDLOSK: I am fifty Mr Drogheda

DROGHEDA: And how does that detract from their perfection since your age is your form and your form is the subject of my fascination?

LOT: *(Bitterly.)* HE HEARS THIS HE IS NOT DEAF HE HEARS ALL THIS

DROGHEDA: Then let him sit in silence

LOT: *(A terrible intuition.)* No

No

(The WAITER writhes as he is stricken with deafness.)

No

DROGHEDA: Everything you say contributes to his misery

LOT: Then punish me since it is I who offends you

DROGHEDA: God loves you

(The WAITER, grasping his altered condition, staggers to his feet, toppling the chair as he does so...)

Which is not to say you are immune from His resentment

LOT: *(Assisting the WAITER, who shakes his head and streams tears.)* It's all right it's all right it's all right

SVERDLOSK: It's not all right is it not really all right he is blind deaf and dumb how is that all right?

(She shuts her bag with a click.)

DROGHEDA: This resentment is understandable given your reluctance to obey Him

LOT: *(To the WAITER.)* Sit

Sit

(He picks up the fallen chair. SVERDLOSK kisses DROGHEDA, one hand lifted to his face...)

Sit you poor boy

(He assists the WAITER into the chair.)

Perhaps I am reluctant yes certainly I am it's obvious I am reluctant to obey Him and these acts of wanton cruelty by you His agent and His angel incline me to think my reluctance is entirely justified

(To the WAITER.)

Oh how terrible it is this silent weeping

(To SVERDLOSK.)

A handkerchief darling darling a handkerchief

(He extends a hand, unaware of SVERDLOSK's preoccupations.)

Handkerchief

(He turns, sees her lingering kiss. He watches it. He moves away from the table to observe the kiss from a new perspective. He is filled with awe... the kiss ends, and SVERDLOSK, opening her handbag again, removes her compact and sets about restoring her face. DROGHEDA is pensive.)

Sodom has its attractions Mr Drogheda even for one who purports to recoil from it apparently

SVERDLOSK: Shh

LOT: Not that we dare expect this brief transaction to diminish in the slightest your determination to destroy this city and all of its inhabitants

SVERDLOSK: Shh

LOT: Including presumably the woman with whom you have enjoyed this brief intimacy

SVERDLOSK: Shh I said

LOT: On the contrary

(The WAITER rotates in his chair, his face taut with incomprehension…)

I have no doubt this lapse from your own high standards will only intensify your contempt for us

(The WAITER tumbles off the chair, sprawling…)

SVERDLOSK: *(Snapping shut her compact.)* I wish you did not waste yourself

LOT: Waste myself?

(He goes to assist the WAITER onto his feet, but hesitates, sensing the futility of it.)

How do I waste myself?

SVERDLOSK: Always you argue always you dissent

LOT: Possibly

SVERDLOSK: Your gaze is like a reprimand and always you frown the frown is permanent I love you but you will not live long

(She turns her gaze to DROGHEDA.)

He knows no peace my husband neither in sleep nor in between my legs it is scarcely a compliment to a woman and it gives me no satisfaction to announce it but he never knows that loss that sublime loss of self that's love do you darling know the loss of love I don't know why I tell you this presumably because I am a faithless wife and the faithless wife betrays to tell you the deepest secrets of our marriage is a gift to you Mr Drogheda do you appreciate the gift I wonder I will mock him if you ask me to mock jeer or scorn his acts what I cannot do I think is cease to love him our kiss was the beginning I assume let me wipe your mouth the kiss left lipstick stains shall I?

(She holds up a clean handkerchief. DROGHEDA seems paralyzed with introspection...)

Do it yourself if you prefer

(DROGHEDA lifts his gaze to SVERDLOSK. She falters...)

Or don't do it

(He looks. SVERDLOSK recovers.)

It's incongruous I daresay but whilst one is inevitably drawn to a man who has recently come from a woman the visible evidence of the fact in the form of lipstick smears renders him ridiculous and annihilates the sexual authority he might otherwise have enjoyed strange strange isn't it

(She looks to LOT.)

Do you find that strange?

(And back to DROGHEDA.)

Please take it off

(She holds out the handkerchief again. Her eyes fix his. At last DROGHEDA takes the handkerchief. SVERDLOSK opens her bag and holds up the compact mirror for him. He dabs his mouth...)

LOT: I know nothing about

SVERDLOSK: Liar

LOT: Sexual love and its

SVERDLOSK: Liar

LOT: Ambiguities

SVERDLOSK: Lying

Lying

Liar

(She laughs briefly.)

My lie is I am not clever yours is you are ignorant of sexual
love from these preposterous fallacies we have made a life
a life which thanks to Mr Drogheda is coming to an end a
woman who has been intimate with an angel presumably
cannot simply return to the marriage bed a little soiled
a little bruised a little absentminded as she is used to
doing when returning from the passion of a mortal man
impossible I should have thought Mr Drogheda already I
want to kiss you again already

*(DROGHEDA is still, the handkerchief clutched in his hand... at
last he looks up)*

DROGHEDA: Wonderful is the wife of Lot

*(SVERDLOSK is moved by DROGHEDA's compliment. She is briefly
honest.)*

SVERDLOSK: Thank you

(She lowers her eyes.)

Thank you

(Pause. She lifts her eyes again.)

To find me wonderful is not incompatible I think with the
sadness I know you are experiencing not incompatible
at all you sense your passion for me will damage your

life but at the same time you long to be damaged I know
this agony I have been where you now find yourself not
once but many times and what is worse for you you find
me cruel and self-obsessed apprehensive is Mr Drogheda
when he contemplates the wife of Lot the wife of Lot has
her own name incidentally

*(DROGHEDA cuts her off with a swift gesture of his hand. LOT
laughs briefly…)*

Naked even I must remain the wife of Lot the angel is a
man then and takes a man's delight in wife-stealing often
I am stolen Mr Drogheda but I remain Lot's wife this will
frustrate you as in the end it frustrated all the others

*(LOT goes to his wife and places his hands gently on her shoulders…
DROGHEDA contemplates their complicity… the stricken WAITER
crawls in, having made a fatuous and circular journey. In a spasm
of resentment, DROGHEDA jumps off his chair and going to the
WAITER, drags him half-upright.)*

DROGHEDA: IF YOU ENTER MY SIGHT AGAIN

LOT: He's deaf

DROGHEDA: CRAWLING AND DRIBBLING AND

LOT: He's deaf Mr Drogheda

DROGHEDA: AND MAKING MOCK OF ME

LOT: You did it Mr Drogheda

DROGHEDA: *(Glaring at LOT.)* I DID IT YES AND SO WHAT IF
MY ANGER STRIKES YOU AS CONTRADICTORY

*(SVERDLOSK laughs, shaking her head. DROGHEDA looks at her.
He lets the WAITER fall. He returns to his chair.)*

Yes and certainly there is something nauseating about
marriages like yours the darker aspects of which seem
impenetrable as primeval forests but which we both know
perfectly well are choked with nothing more exotic than
self-interest and complacency this sordid encounter has

delayed my departure but since you are determined to perish here I need not test God's patience any further I am in love with you but that is a fact which can be objectified and then abandoned as one abandons a chair as one abandons a table the table is a fact so what

(SVERDLOSK and LOT look at DROGHEDA, who does not move. DROGHEDA frowns. The WAITER, attempting to rise, trips and sprawls…)

So what

So what

(DROGHEDA stands as if to depart, but is hesitant…)

SVERDLOSK: Shall we go to a room?

(DROGHEDA is silent. His mouth moves in his crisis.)

We can go to a room but frankly that is not my way and in any case a room chosen by you will inevitably possess all those characteristics I found so distasteful in your choice of café an unaired bed a carpet so soiled I will hesitate to set a naked foot on it dead flies and threadbare curtains of course my foot need not be naked by all means let us make love in shoes but in my own home in my own home let us violate all those things conventionally described as homely and there are more shoes there not only red but black or blue

(DROGHEDA does not reply. His head turns in his discomfort…)

DROGHEDA: I have to say this and it will not I think come as a surprise God knows His own mind but speaking for myself I hate the pair of you

(SVERDLOSK laughs brightly…)

LOT: Shh

DROGHEDA: A hatred possibly more bitter because as we all three know I am in love with you in love with what however the miniature scale of your transgressions the

pitiful collusion of your book-collecting husband the suffocating stench of an airless domesticity

(SVERDLOSK laughs again.)

LOT: Shh

DROGHEDA: Combine to make me shrink from you

SVERDLOSK: *(Standing up.)* Follow me

DROGHEDA: *(Pursuing his indictment.)* Sin or the idea of sin to be precise

(She brushes her suit with a gloved hand.)

SVERDLOSK: Follow me now

DROGHEDA: Excites you

SVERDLOSK: It is good to follow a woman is it not?

DROGHEDA: But what sort of sinner are you?

SVERDLOSK: Following and knowing?

DROGHEDA: No sinner at all

SVERDLOSK: Knowing she will be naked knowing that while she walks she trembles

DROGHEDA: But an imitation of a sinner

SVERDLOSK: Trembles with the thought of you

DROGHEDA: A copy a

SVERDLOSK: She marches and she throbs

DROGHEDA: A copy

SVERDLOSK: With fear and hope with hope and fear

DROGHEDA: A COPY I SAID

(The WAITER, trying to haul himself upright, pulls the table on top of himself. DROGHEDA, SVERDLOSK, even LOT, pay no attention.

With exquisite decision, SVERDLOSK goes to leave. DROGHEDA stands abruptly.)

I love you where are you going I love you

(SVERDLOSK stops, her back to DROGHEDA…)

LOT: *(Supremely complacent)* To the library

(DROGHEDA casts a withering glance at LOT.)

She is going to the library

(DROGHEDA's lip trembles with his resentment.)

To be naked in the library or a little naked in the library

(His gaze is unfaltering.)

To stand in the library in perfect nakedness or simply
to disarrange her clothes as if the books were dead men
gazing on her I don't know as if the intellectual character of
the room pleaded for its violation I don't know as if as if

(He smiles thoughtfully.)

I really do not know and she leaves nothing after her so
when I return to study there the library retains that air of
sacred and impenetrable secrecy which the smallest relic
of her presence a handkerchief a button even a single
thread of her underwear would violate she knows this and
is fastidious

(He heaves the table upright…)

Sodom is an ugly place but where else should I go Mr
Drogheda I am in the library the library is in me a place
of scholarship but not always scholarly nakedness and the
book the book and nakedness ask God to forgive us I shall
never find again the simplicity He demands of me and
she has never in her life lifted a spade or planted a solitary
geranium look at her Mr Drogheda her shoulders are more
fragile than a child's does God seriously propose those

shoulders haul buckets out of wells does He do you Mr
Drogheda?

*(Pause. SVERDLOSK's head turns to DROGHEDA. Her look
commands him. She goes out. DROGHEDA stares at LOT, then turns
and looks after SVERDLOSK. He follows her. LOT is still. The WAITER
is silently turning on the ground like a dying insect. At last LOT
emerges from his meditation. He goes to the WAITER and takes both
his hands in his own. He hauls him up and edges him into a chair,
where he sits swaying, his head in his hands. LOT himself sits…)*

She wants him

(Pause.)

I could see that as soon as I came in you read the signs you
feel the feelings it could be in a look the way the hips slip
down the chair anyway she soon admitted it they must be
crossing the river as we speak as I speak you do not speak
obviously

*(Pause. The WAITER's hands comb the air. LOT takes one hand and
holds it…)*

Unless and I have often seen this done on bridges unless
she drifts to a standstill staring over the parapet one heel
a little raised and parked behind the other pensive so it
appears of course not pensive in the least as he draws
nearer sets off again that takes time all refinements take
time few have the patience for refinements turning
the corner she will look back conventional you say
conventional of course but in matters such as this the
conventional finds it apotheosis to innovate at this
stage would compromise the fragile and exquisite faith
which makes such extraordinary intimacies possible no
innovation comes later her key is in the lock she lingers
pretending the door is stiff lingers until he arrives at the
bottom of the steps from his perspective her legs look oh
her legs look so the door swings open as we speak as I
speak you do not speak obviously and climbs the stairs she

leaves the door ajar and climbs the stairs the library is on
the first floor only a little ajar these details are significant

*(Pause. The WAITER's free hand gropes the air, discovers LOT's head
and strokes it, pitifully. LOT does nothing to discourage him…)*

She

(He smiles at the delicacy of the WAITER's touch.)

She

*(He kindly removes the WAITER's hand and places it with the other,
his own hand covering both.)*

She walks directly to the table about a dozen steps the
table not the desk the desk is heaped with objects any one
of which could topple roll and smash minor accidents
cause anguish in these circumstances out of all proportion
to the value of the property no she avoids the desk she
stands instead behind the table one hand idly posed on
it the hand without the glove the ungloved hand pale in
its nakedness the gloved hand she raises to her chest the
gloved hand holding the glove do you follow and looks
towards the door tilting her head so this first glance is dark
conspiratorial a pact once this long and awful look has
been exchanged she takes off the hat

(He stops.)

I think

I think she discards the hat and for this reason that their
first kiss might be stripped of its magnificence if in his
impatience he dislodged the hat not only that not only that

(Pause.)

In lifting both hands to remove the hat one to the pin
the other to the brim a woman shows herself to immense
advantage the light falls on her hair her undressed hair is it
not a gift to him a promise even as we speak he as I speak
you do not speak obviously he he he

(He stops, yielding to his meditation. His face expresses pain and ecstasy at once. At last he stands, depositing the WAITER's hands on the table. The WAITER is docile. LOT walks a little…)

Conceal yourself she said and from your hiding place observe me never have I done so and I must admit the proposition caused me some offence whilst acknowledging she extended this invitation as a testament of love it had the unfortunate effect of causing me to recognize the limitations of her sensibility to witness such a sacrament might well enthral me and I saw even to speak of it enthralled her but there is a greater place from which to sense the world a colder place cold but immaculate I was disappointed this was impossible to communicate to her there were other considerations for example would the fact of her husband being present and observing her cause her to act differently to exaggerate her feelings no there is an integrity in all encounters which has to be observed they're late

(He frowns. He bites his lip…)

Late and I am perfectly aware a couple returning from an intimacy how funny I do not like that word intimacy the word I do not think I ever have described these acts as intimacies I am both irritated and curious to know why I employed the word a couple walk more slowly from their union than they walked towards it I like union even less certainly they're late they're late whatever the word is

(He stares into the distance. He draws the back of his hand across his mouth. He sits in the chair. He stares at the ground. He frets. The immobile WAITER speaks.)

GOD: Lot

(Pause. LOT is uncertain if he heard his name. He lifts his eyes.)

Yes I spoke your name does it surprise you when God speaks through a dumb man's mouth?

(LOT shifts on his chair. He looks at the mask of oblivion that is the WAITER's face…)

LOT: No

No

No it is entirely predictable in God the wonderful is predictable any appearance of contradiction in that statement lies in the poverty of my understanding Mr Drogheda an angel is with my wife

(Pause.)

Naked with my wife that also is a contradiction only in so far as I fail to understand it he drew her skirt over her hips he took her from behind he he

(He closes his eyes in his agony…)

Her hat her gloves were on the table no not gloves one only one glove lay on the table the other she wore as he as he

(He stares at the ground…)

GOD: The angel does my will

(Pause.)

LOT: Does he? Does he do God's will?

(He bites his lip.)

Then neither his reluctance nor his fascination was sincere?

(He frowns.)

GOD: Lot's wife

LOT: Her name is

GOD: Lot's wife is Lot's property if she were not Lot's property she could not be stolen if she could not be stolen all that happens in his library would yield Lot no pleasure Lot's wife is therefore her whole identity

LOT: God knows us

(He works at his fingers in his anxiety.)

And because He knows us knows also the great dread that constitutes Lot's ecstasy the dread she

(He bites his lip.)

WHERE IS MR DROGHEDA?

(He stares into the adamantine face of the WAITER…)

It's cold I'm

(Pause.)

Evening's coming on we never

(Pause.)

My wife and I have solemnly agreed she never stays longer than

(Pause.)

Or I fret obviously

(Pause.)

Strangers however nice they seem to be are AND THIS IS SODOM

(He suddenly rises out of his chair.)

IF HE HAS HURT HER I WILL

HAS HE

HAS HE

(He goes to threaten the WAITER. He stops on a thought.)

No

No

It's worse

She loves him and she

(*He half-laughs. He slumps into his chair*)

HAS PACKED A BAG

(*He stares, racked by imagination…*)

A taxi to the station a train to the ferry and in their cabin an act which entirely excludes me

(*He appears to dream…*)

GOD: Sixteen times Lot's wife betrayed him

LOT: Sixteen is it I never counted them SIXTEEN I DON'T THINK SO can one betray a man who yearns for his betrayal who finds the very word exquisite SIXTEEN you are playing with me you are implying there have been occasions of betrayal to which I was not party authentic infidelity therefore not her not her not her SIXTEEN now you think me sentimental you think the idiot husband fawns upon his wife you

(*He stops.*)

Yes

Yes

(*He frowns.*)

Sixteen if you say it is

(*He makes fists of his hands. He shakes his head*)

Nothing spoils sin like giving sin permission

I ADMIRE HER

(*He affects to laugh.*)

ABUNDANT IS MY WIFE'S IMAGINATION HOW COULD SHE ALLOW HER INFIDELITIES TO BE POLICED BY ME IT'S PREPOSTEROUS SIXTEEN YOU SAY ONLY SIXTEEN ARE YOU SURE IT ISN'T MORE

I love her

I love her

How beautiful are the lies of Lot's wife how beautiful her truth

(His eyes fill with tears.)

Let her eyes look on me narrowed with their secrets how terrible it is to know all things I pity God I would not be Him

(The WAITER is still, then to LOT's horror he begins to weep. LOT stares…)

Forgive me

Forgive me my vast love my vast but mortal love of my own wife pitiful as it surely is

(GOD sobs. LOT's hands rise and fall futilely.)

Stop that

Stop that awful sound

(He covers his ears as GOD moans in his solitude. SVERDLOSK enters holding a packed bag. She looks at the WAITER.)

SVERDLOSK: Wasn't he dumb?

(LOT turns to his wife.)

Wasn't he deaf?

(LOT grasps his wife's hands and covers them in kisses. The WAITER walks away, faultlessly.)

Wasn't he blind the waiter?

(She looks down at LOT. With a profoundly loving gesture she places her gloved hands on his head and kisses him. LOT's gaze falls on the bag. At the same moment DROGHEDA walks in, sullen but patient. LOT's face is ghastly.)

LOT: You're leaving me

(SVERDLOSK frowns.)

You're leaving me and from some redundant sense of manners feel it necessary to perform this adieu and I imagined you already on the ferry petting as the throbbing engines churned the sea the gulls the fading cliffs or in your cabin yes straight to the cabin never mind the view clothes chasing clothes flung heaped chaotic hat gloves shoes entirely different from the library the library having been however breathless still discreet still constrained by etiquette and the moves few few moves in the library the effect of literature perhaps the sheer weight of philosophy moderating urgency and making both of you infinitely

SVERDLOSK: There is no library

(LOT stares at his wife.)

You know Mr Drogheda he

(Pause.)

Has tempers destructive tempers destructive not only to men also to property

(Pause.)

It's burned the library

(LOT cannot speak. DROGHEDA takes a chair and turning it, sits…)

DROGHEDA: Unhealthy place

LOT: Oh?

DROGHEDA: Menacing

LOT: Menacing?

DROGHEDA: *(Shooting a cruel look at LOT.)* It menaced me

(Pause.)

Up to a certain point I found it stimulating obviously the shelves of arid argument and her naked arse the meditations of the dead and her fingers searching me gloved fingers incidentally then I lost my temper

(DROGHEDA rocks on his chair, his eyes fixed on LOT.... LOT disdains to quarrel... his horror subsides...)

LOT: The angel does God's will it is a pity however that he could not be satisfied to steal my wife perhaps I always sensed this was a destiny and the books intended for my consolation I am to have no consolation it appears

(DROGHEDA stands and goes to LOT. He searches his face, frowning...)

DROGHEDA: What are you?

(LOT does not lift his eyes to DROGHEDA.)

LOT: A man more sensitive than God thought men could be

(Pause.)

No wonder He hates Sodom

(He lifts his eyes to DROGHEDA.)

No wonder he thinks the desert is the place for me

(He creates a smile.)

Churlish and arbitrary is God but my ordeal is obviously necessary to me

(His eyes fall.)

I submit to His will

(He looks up again to DROGHEDA.)

Bookless and wifeless Lot will be

SVERDLOSK: Wifeless?

LOT: Under a bitter moon Lot will discover death or some other poetry than woman possibly

SVERDLOSK: How wifeless?

(DROGHEDA laughs brutally. SVERDLOSK turns on him.)

If I had heard that laugh even an hour previously never would you have visited me it is a dog's laugh the angel is a dog

DROGHEDA: Stroke your dog

SVERDLOSK: *(To LOT.)* The bag's for us

DROGHEDA: Stroke me

SVERDLOSK: Towels socks handkerchiefs

DROGHEDA: Don't stroke then it's a funny thing

(He drags the chair to himself and sits astride it.)

A funny thing the act of love I call it love I dignify the thing that has so many names it masquerades as a conclusion all that attaches to it confirms it is the end when all the time it begs for repetition hardly had I got to the foot of the stairs the smouldering stairs the stairs already thick with ash when the sight of her descending bag in one hand the other lifted to her tilted hat struck me with the force of an irresistible proposition it was as if we had completed one transaction only to discover this compulsion for another and that this also whilst seeming to be final would coerce us yet again into another and another and

SVERDLOSK: *(Discreetly.)* Shut up

DROGHEDA: As we struggled in the smoke-filled hall

SVERDLOSK: Shut up now

DROGHEDA: I sensed this was only the first instalment of a servitude

SVERDLOSK: Shut up I said

DROGHEDA: STROKE ME THEN

(He shrugs. He turns his shoulders away.)

SVERDLOSK: *(To LOT.)* Your razor I remembered but the soap I don't think I collected

DROGHEDA: NEVER STROKE ME AGAIN

SVERDLOSK: I was choking I could hardly see

DROGHEDA: NEVER NEVER STROKE AGAIN

SVERDLOSK: Use mine if necessary

(DROGHEDA smothers his head in his hands… LOT gawps at his wife. Suddenly DROGHEDA flings out of the chair.)

DROGHEDA: Leave by the East Gate if you have friends do not delay your departure by bidding them farewell they're dead and do not stop at Zoar pass through Zoar you may not exchange one city for another the life you have led here hurt God but still He pities you now give me one shoe you will find no use for high heels where you are going either will do

(SVERDLOSK removes one shoe and extends it to DROGHEDA. DROGHEDA studies it without taking it. He lifts his eyes to SVERDLOSK)

Exquisite perversity

(He seems to suffer. His hands open and close. He shakes his head.)

LOT: *(Kindly.)* Take it

(DROGHEDA is dark with resentment…)

Take it I understand how you

DROGHEDA: *(With a surge of rage.)* DO YOU DO YOU UNDERSTAND GOD IT MUST BE AND GOD ALONE STOPS ME BLINDING YOU

(His eyes return to the shoe, patiently held by SVERDLOSK.)

Preposterous and ridiculous refinement of a culture of depravity

(Pause. SVERDLOSK does not withdraw the shoe. DROGHEDA takes it.)

Hobble

(He smiles grimly.)

Hobble your absurdity will mock my idiot's infatuation

(The WAITER, crawling and slithering, enters as before, dumbly plucking at the air. DROGHEDA studies him.)

Pity the waiter

(LOT casts a glance at the man.)

Pity his writhing but is it more grotesque than yours?

(DROGHEDA walks out. SVERDLOSK watches his departure, then swiftly sits, unzipping her bag and deftly removing a pair of identical shoes. She selects the one necessary to restore her equilibrium. She stands. She saunters a little, as if before a mirror in a shop. LOT's eyes follow her practised moves…)

LOT: The desert

(He frowns, biting his lip in his longing.)

The desert I think might be

SVERDLOSK: The angel entered me

(She stops. Her look challenges her husband.)

Entered me and

LOT: We never discuss the

SVERDLOSK: Never discuss them no

LOT: The details never never

SVERDLOSK: No and having entered me or whilst inside me

LOT: Inside

SVERDLOSK: Inside me said

LOT: Inside

(LOT suffers.)

Inside you yes

Inside

Inside

(He runs his hands through his hair.)

Inside you

(He shakes his head.)

Terrible words inside you inside you yes

(He exerts his concentration.)

Said what

Said what inside you?

(He aches.)

SAID WHAT?

SVERDLOSK: God wants me dead

(Pause.)

In order to save you

(She looks at the floor.)

Run away with me said Mr Drogheda not said he begged and everything was just as you described it taxi train and ferry the seducer is predictable and the seduced no less predictable she said I love my husband

(She laughs mildly…)

Which I do

(They look at one another, agonized and pitiful…)

I then went to the bathroom in the bathroom I smelled smoke

LOT: God works through Mr Drogheda

SVERDLOSK: I grabbed a bag

LOT: A wife would

SVERDLOSK: I grabbed a bag and packed it I did the thing I said I'd never do except I did not pack it I threw things in I threw whatever I

(LOT leans to the bag and opens with the fingers of one hand…)

LOT: Lipsticks

Stockings

Shoes

SVERDLOSK: *(Unreproached.)* Yes

Yes

And are they not the things most precious to you?

(LOT rises from his chair and embraces his wife, running his hands over her body with an insatiable possessiveness, at once sublime and pitiful. The WAITER, observing, is a sculptural tribute to their passion. LOT parts from SVERDLOSK. He takes the bag, and his wife by the hand. His attention is distracted by the WAITER.)

LOT: Can't take you

(He frowns. An urgency seizes him.)

CAN'T TAKE YOU

(He draws his wife away. They hurry out of SODOM.)

*

RESISTING GOD

Something of what it is to be a European lies in the haunting of the culture by its great texts, both visual and literary. These ancient narratives itch with their unresolved dilemmas, their cruel and senseless propositions, their frustrating irresolutions, and they rise like ghosts to mock our moral platitudes, as if every age required to interpret them again. I have returned to these sources frequently, not in some dutiful scholarship, as an artist might copy old masters to improve his own style, but because some incongruity claimed my attention which could not be simply consigned to time expired theologies of the past. Thus I have excavated both testaments of the Bible, classical myth and history, and works of fiction now religiously preserved in the pantheon, even of quite recent time. My ECSTATIC BIBLE alludes to its unecstatic predecessor, and borrows its forms: THE LAST SUPPER interrogates Christ's reluctant suicide: JUDITH, eponymous heroine of the Apocrypha, asks if her sacrifice is not greater than her triumph: URSULA dissents from the contemporary contempt for virginity: THE BITE OF THE NIGHT mediates on the erotic infallibility of Helen of Troy. With regard to theatre classics, I have puzzled over the moral lassitude of UNCLE VANYA and praised the passion of GERTRUDE from Shakespeare's play. Now I am writing the spoken text to Velasquez's LAS MENINAS, arguably the greatest picture ever painted. If the invention of new fictions is the first instinct in a dramatist, it seems to me argument with the fictions of the past must be the second.

So to LOT AND HIS GOD. The apparent vindictiveness of God in atomizing a harmless woman in the Genesis story is both cruel and typical of the Yahweh of the Old Testament and so scarcely worth disputing for its justice or injustice. What remains moving is the inexplicable fact of her **looking back**, for it can only be nostalgia for Sodom that could make a wife look back to such a place, knowing full well its sordidity and God's intention to consume it in fire. On contemplating this reckless look, I could only think it exquisitely justified: she dies in preference to obeying the order to move. What's more, her life as I conceived it, is something superior to morality – a work of art …

Howard Barker

OTHER HOWARD BARKER TITLES

Scenes from an Execution

ISBN: 9781849434683

The Ecstatic Bible

ISBN: 9781849434171

BLOK/EKO

ISBN: 9781849431101

The Seduction of Almighty God

ISBN: 9781840027112

Slowly / Hurts Given and Received

ISBN: 9781849430166

Dead Hands

ISBN: 9781840024647

The Fence in its Thousandth Year

ISBN: 9781840025712

Barker: Plays One

ISBN: 9781840026122

Barker: Plays Two

ISBN: 9781840026481

Barker: Plays Three

ISBN: 9781840026764

Barker: Plays Four

ISBN: 9781840028515

Barker: Plays Five

ISBN: 9781840028867

Barker: Plays Six

ISBN: 9781840029611

—

A Style and its Origins

by Howard Barker, Eduardo Houth

ISBN: 9781840027181

Theatre of Catastrophe:
New Essays on Howard Barker

edited by David Ian Rabey and Karoline Gritzner

HB ISBN: 9781840026948
PB ISBN: 9781840026726

WWW.OBERONBOOKS.COM

 Follow us on www.twitter.com/@oberonbooks
& www.facebook.com/oberonbook

www.ingramcontent.com/pod-product-compliance
Ingram Content Group UK Ltd.
Pitfield, Milton Keynes, MK11 3LW, UK
UKHW020729280225
455688UK00012B/560